T0016688

YOSEMITE FALLS

YOSEMITE ICON

YOSEMITE CONSERVANCY

YOSEMITE NATIONAL PARK

Yosemite National Park is famous for many reasons, but it's especially renowned for its profusion of flowing, tumbling water. Look closely at a map of Yosemite, and you'll find at least twenty notable waterfalls—and those are just the features with official names. Myriad small, anonymous cascades spill down cliffs and banks throughout the park.

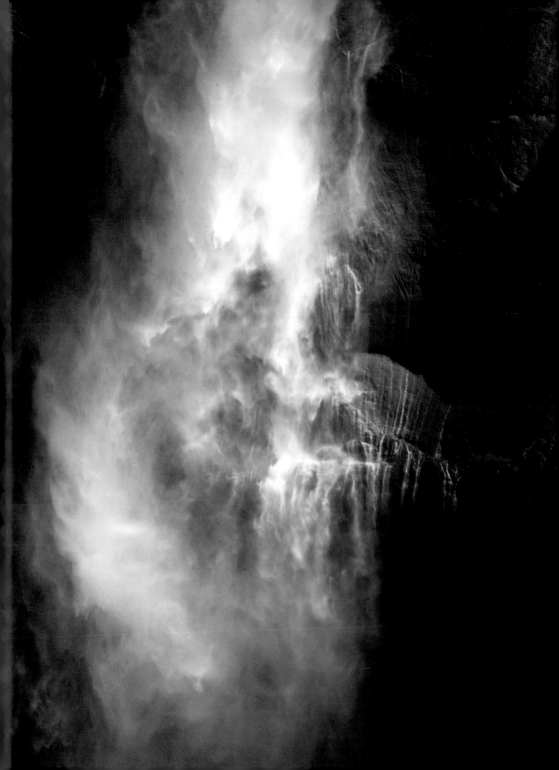

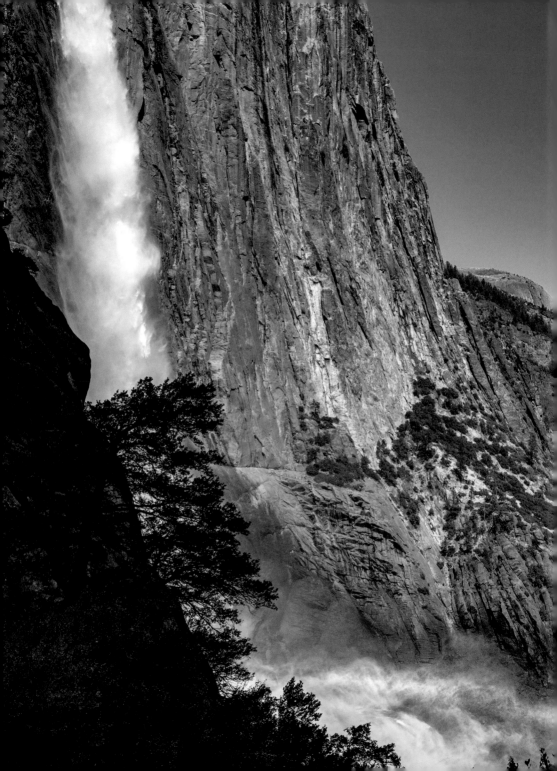

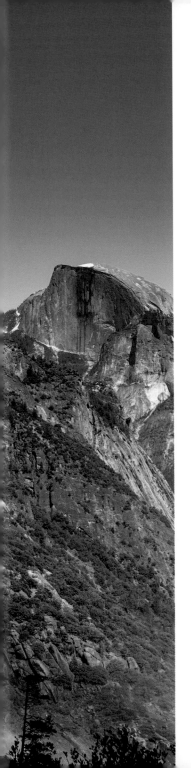

We have ancient geologic processes to thank for these stunning displays of falling water. Most of Yosemite's best-known falls—including the subject of this book—flow down granite. Eons ago, Yosemite's granite was molten rock, which then solidified far underground and became exposed as overlying rock eroded away and the Sierra uplifted. Over time, it tilted to the west and formed the wedge-shaped Sierra Nevada. Rivers, rockfalls, and glaciers sculpted and sanded the land, leaving smooth cliffs and domes, spindly spires, U-shaped valleys, leaping waterfalls, and the occasional erratic boulder dropped by slow-moving ice.

The park's 1,187 square-mile (3,074 km²) area support an enormous amount of biodiversity. At Yosemite's lowest elevations, in the foothill-woodland zone, scarlet-barked manzanitas take advantage of mild winters. A little higher up, in the lower montane zone, giant sequoias soak up snowmelt with wide, shallow roots. In the harsh exposed climate of the park's highest elevations, the alpine zone, purple sky pilots grace summits at elevations surpassing 13,000 feet (3,962 m).

Yosemite's varied habitats support diverse wildlife, from common animals, such as coyotes, squirrels, and deer, to notably rare species: Sierra Nevada bighorn sheep dwell on high slopes and plateaus, tiny Yosemite toads live in forests and wet meadows, and great gray owls nest in broken or burned treetops.

The water in Yosemite flows through two watersheds: the Tuolumne River watershed, which drains the northern part of the park, and the Merced River watershed, which drains the southern part. A snowflake that lands somewhere in the Tuolumne River watershed may one day wind up in somebody's drinking glass in San Francisco, after a long journey involving Hetch Hetchy Reservoir. Meanwhile in the Merced River watershed, melted snowflakes flow from the high country through creeks and canyons before leaping over the rim of Yosemite Valley. Much of the water that flows through and out of the park ends up being used to irrigate crops in California's Central Valley.

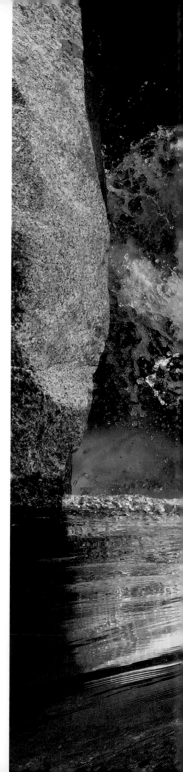

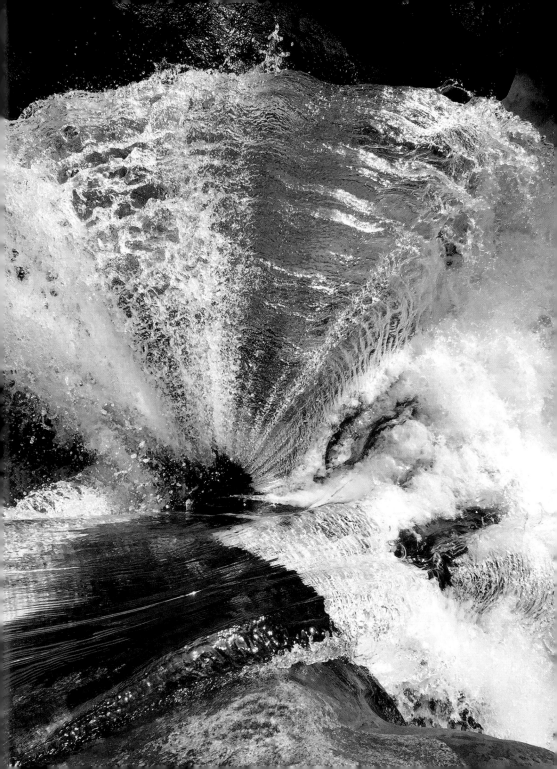

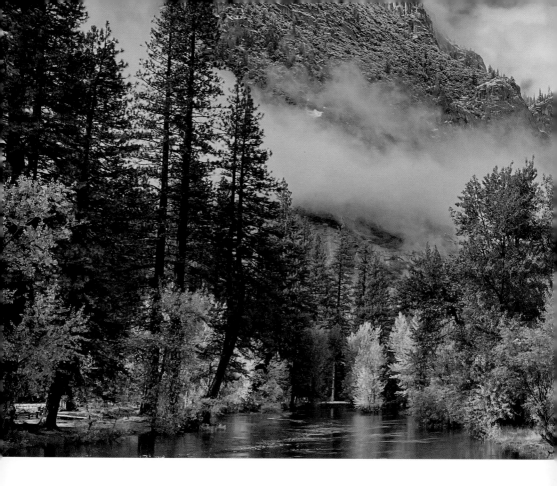

Yosemite is home to seven indigenous tribes, whose people have resided in this area since time immemorial. The tribes retain deep cultural, spiritual, and ecological ties to the land. When exploring Yosemite, please remember that this place is still home to the seven tribes, who ask that you treat this sacred landscape with the utmost care and respect.

Nothing embodies Yosemite's geologic and human history more clearly than the celebrated natural features known as *the icons*. They share common traits: instantly identifiable,

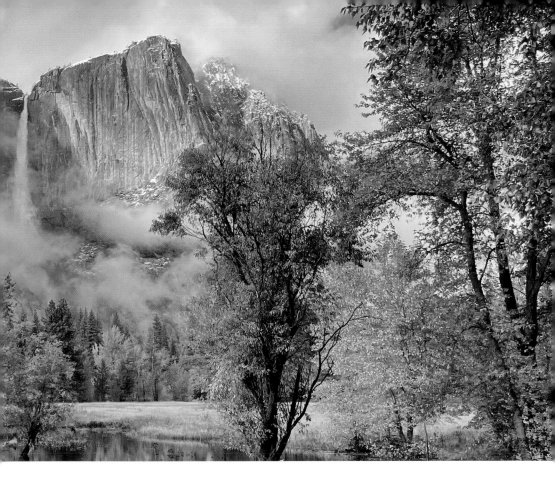

unique to the park, culturally significant, and enormous.

Yosemite Falls easily holds a top spot among the must-see natural wonders of the park. This iconic feature, the product of multiple interconnected waterfalls tumbling down the side of Yosemite Valley, offers up spellbinding scenery, cool mist, lunar rainbows (or "moonbows"), and a slushy phenomenon called frazil ice. You may already be a fan of Yosemite Falls, but we bet you'll appreciate this dynamic even more after you've gotten to know it a little better. Let's go!

Natural History

No matter how you measure it, Yosemite Falls is huge. It's among the tallest waterfalls in North America and undisputedly the highest in California. A dozen full-grown giant sequoias, stacked roots to crowns, would barely reach the top.

Scientists don't regularly measure the falls' volume, but early twentieth-century measurements showed that at peak flow, about 300 cubic feet (2,300 gallons or 8,700 liters) of water rushes over the rim every second.

You won't have to look hard to find Yosemite Falls midway between El Capitan and Half Dome, on the north wall of Yosemite Valley. And if you find yourself gasping aloud at its powerful yet ephemeral splendor, you'll be in good company; it's easy to fall for the falls. (Sorry, we couldn't resist.)

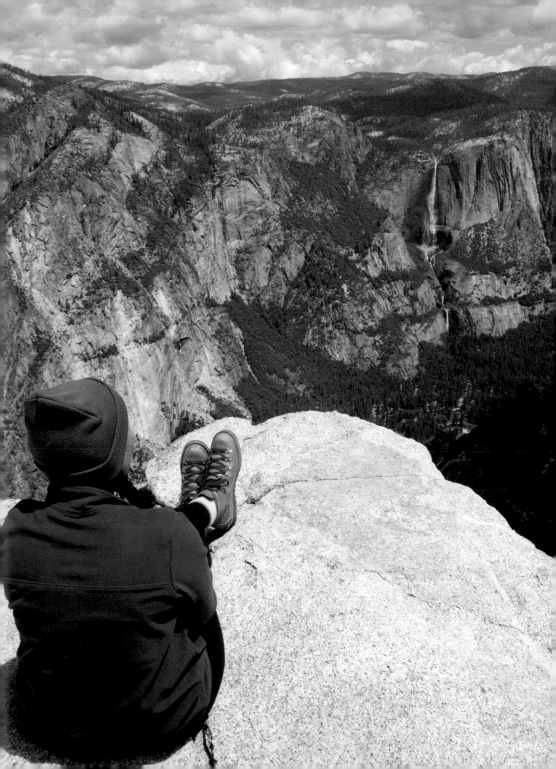

THE BASICS

When you look at Yosemite Falls, you're seeing a creek that had been casually flowing along before—whoosh!—flying off a cliff. For much of its course, Yosemite Creek is a lovely, unremarkable stream. It starts at Grant Lakes, 13.2 miles (21.2 km) north of the Valley at an elevation of about 9,200 feet (2,804 m), and flows southeast, gathering snowmelt. It passes Mount Hoffmann, dips under Tioga Road, meanders by meadows and forests, and then leaps over the Valley's north rim.

That's when the magic starts! From the rim, the sometimes raging, sometimes mellow marvel pours 1,430 feet (436 m) down Upper Yosemite Fall, careens another 675 feet (206 m) through several smaller drops known as the middle cascades, and then plummets a final 320 feet (98 m) through Lower Yosemite Fall. In total, the water descends 2,425 feet (739 m) before crashing onto a rocky bed and then flowing away to finally merge with the Merced River.

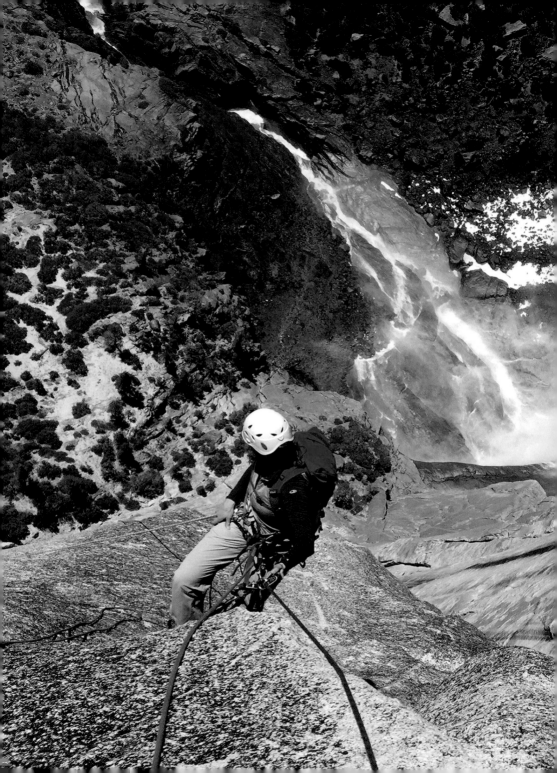

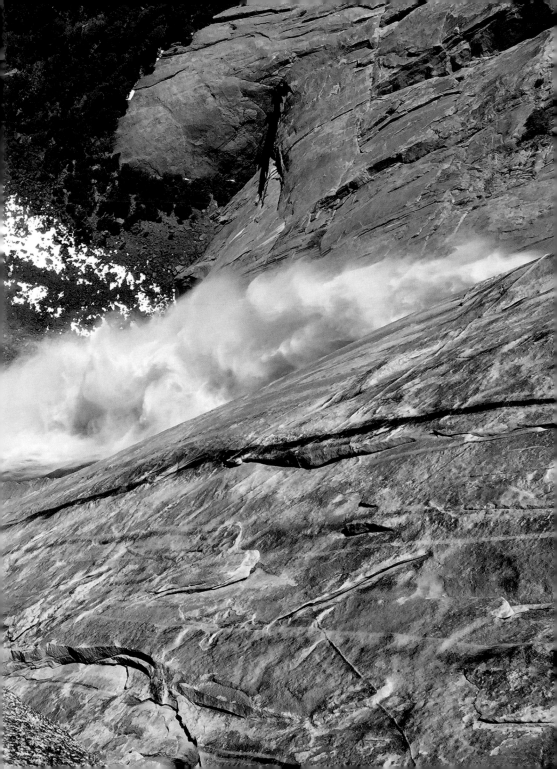

THE BACKSTORY

Back in the Pleistocene epoch, when mastodons and saber-toothed cats roamed California, Yosemite Creek flowed through a steep ravine following the course of today's Yosemite Falls Trail into what was then a much shallower Yosemite Valley. As ancient glaciers grew and shrunk, they scraped and deepened the Valley, leaving tributary streams like Yosemite Creek high above the floor. Glaciers also left behind piles of debris, called moraines, that redirected the creek eastward to its current location.

There's a geologic story behind Yosemite Falls' multipart shape, too. Horizontal cracks in the granite interrupt the downward flow and create a rocky staircase. See the greenery partway up the cliffs beside the falls? Those plants and trees are anchored in those east-west fractures.

In early spring, you'll see Yosemite Falls gush as snow melts into the meadows and streams of Yosemite's high country. The glaciated granite terrain through which Yosemite Creek runs has little soil and few lakes to retain water, and so snowmelt drains quickly—and then it's gone. The falls typically peak in May or June, often dry out entirely by late summer, then revive with autumn rains and sweep down frosted granite in winter.

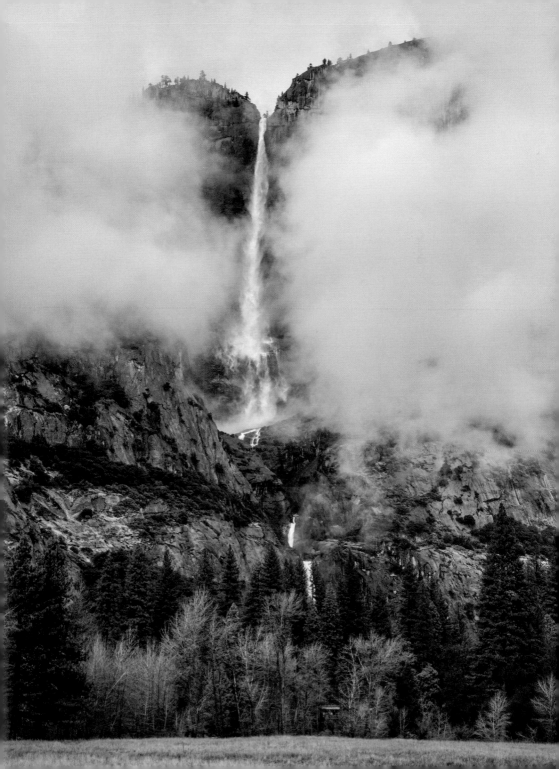

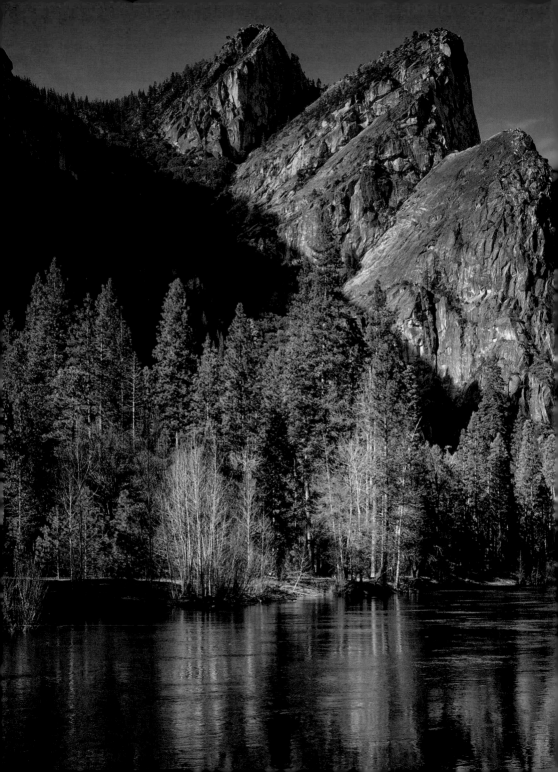

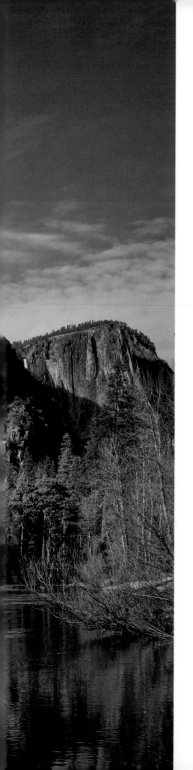

THE SURROUNDINGS

If you can tear your gaze away from Yosemite Falls, you'll find other intriguing natural features nearby. To the west, Eagle Peak, the tallest summit in the Three Brothers formation, stands out as the highest point on the Valley's north side. East of Yosemite Falls, look for Lost Arrow Spire, a granite needle that juts out from the wall.

And Yosemite Falls isn't the only aquatic show in the Valley. Glance east in spring and you might spy fleeting Lehamite Falls dancing down Indian Canyon, the deep gully beside Royal Arches. To the west, framing El Capitan, are Horsetail Fall (famous for resembling a cascade of fire when the light is just right in February) and Ribbon Fall (North America's longest one-drop waterfall). Across the Valley, Bridalveil Fall slows to wispy tendrils by late summer but generally flows in some form year-round.

On some spring nights, you'll see photographers near the base of Yosemite Falls trying to capture moonbows, or lunar rainbows, which are visible to the naked eye but look much better through a camera lens.

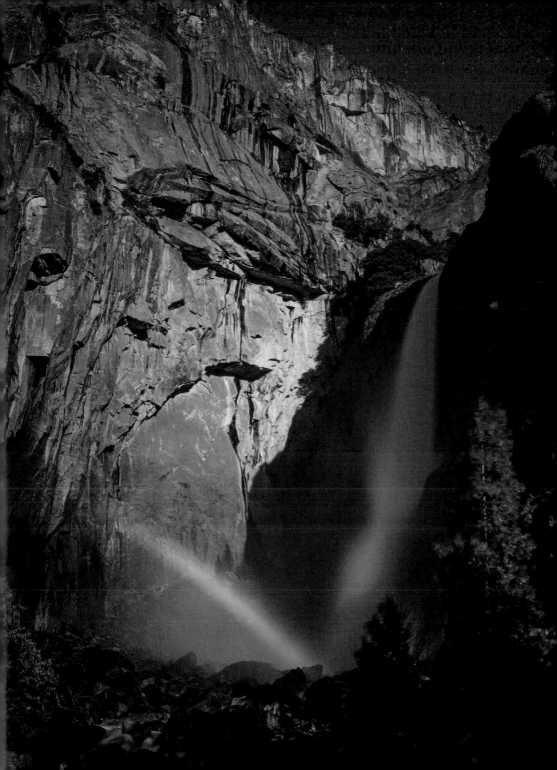

PLANTS AND ANIMALS

The area around this vivacious feature, with its mix of shade, sun, and abundant water, teems with life.

Douglas-firs and incense-cedars thrive around Lower Yosemite Fall. In spring, look for Pacific dogwoods unfurling their creamy petal-like bracts; in autumn, brilliant foliage decorates western azalea growing along Yosemite Creek. Year-round, mosses coat mist-soaked granite boulders.

Mule deer frequent the area around the base of the falls, and coyotes, bobcats, and black bears make occasional appearances. Steller's jays preen and swoop, and American dippers bob for insects in Yosemite Creek. You may also spot American robins, red-shafted flickers, and western bluebirds. California ground squirrels might seek your trail mix, but don't share your food with small mammals (or any wildlife), no matter how plaintive they look. Keeping your snacks to yourself helps protect wild animals by discouraging them from getting used to human food.

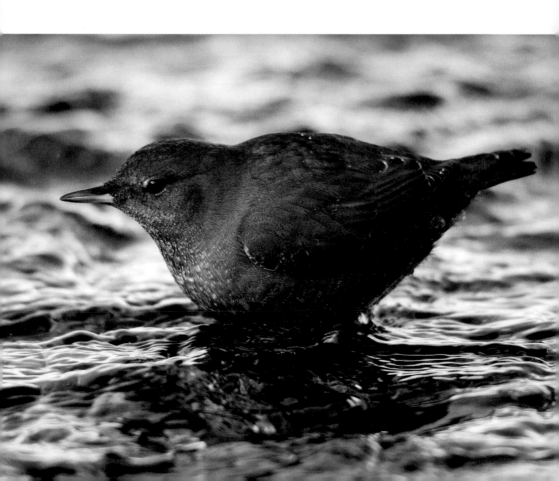

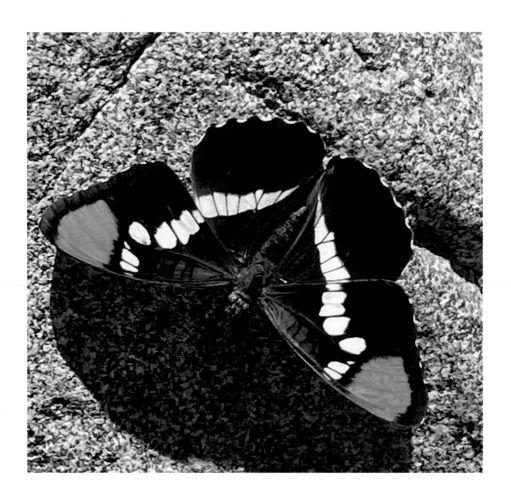

In spring and summer, lupine, milkweed, and other seasonal flowers take advantage of the area's moisture and pockets of light. Butterflies, such as California sisters, with their orange-dotted wings, float among the blooms. In late spring, you might spot parasitic plants such as pink pinedrops and scarlet snow plants, which survive by stealing nutrients from tree-root fungi.

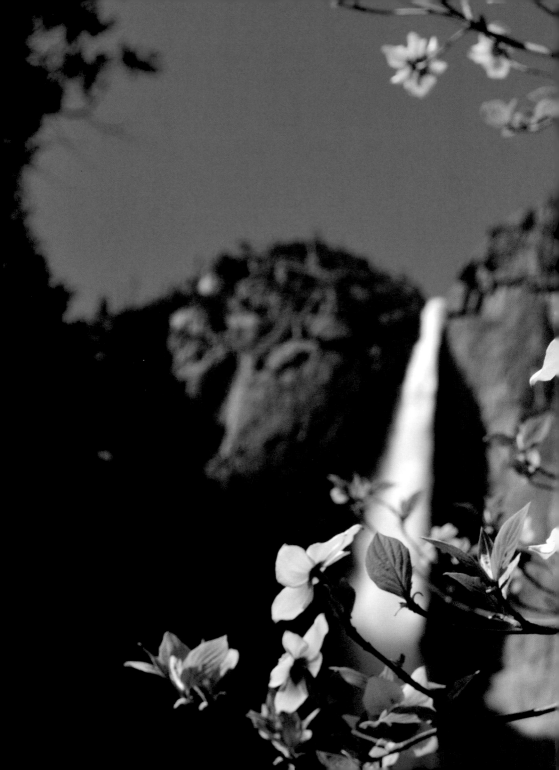

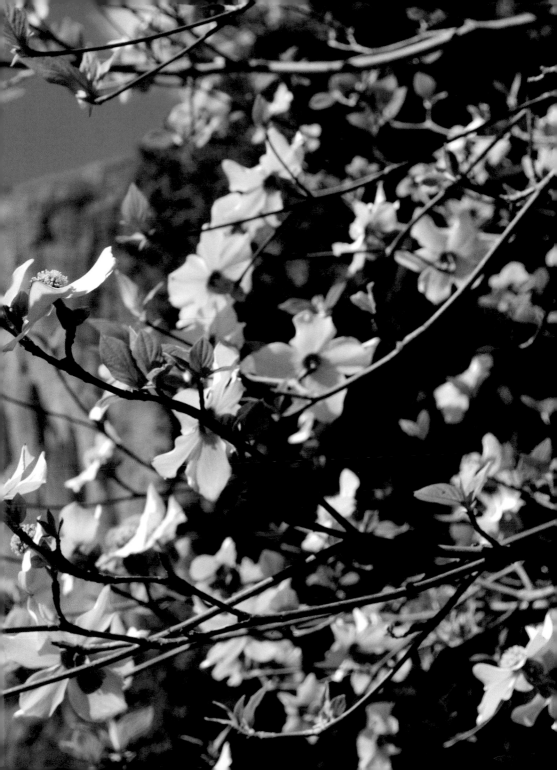

As you hike toward Upper Yosemite Fall, ferns and greenleaf manzanita make for a verdant ascent. Snakes (including rattlesnakes) and fence lizards warm themselves in sunbaked sections. By the time you top out on the Valley's rim, you've moved into a high-elevation ecosystem and may be greeted by pink penstemons and gold-centered mariposa lilies, as well as playful ravens diving and dipping on the wing.

Human History

Each time you see Yosemite Falls, it's both a singular and shared experience. Never again will that same collection of molecules come together for the downward leap.

N ow imagine how many times that capricious combination of hydrogen, oxygen, and gravity has captivated human attention, going back untold generations. The falls echo in stories from many indigenous cultures and languages, and have been the backdrop for a complex and sometimes cruel history.

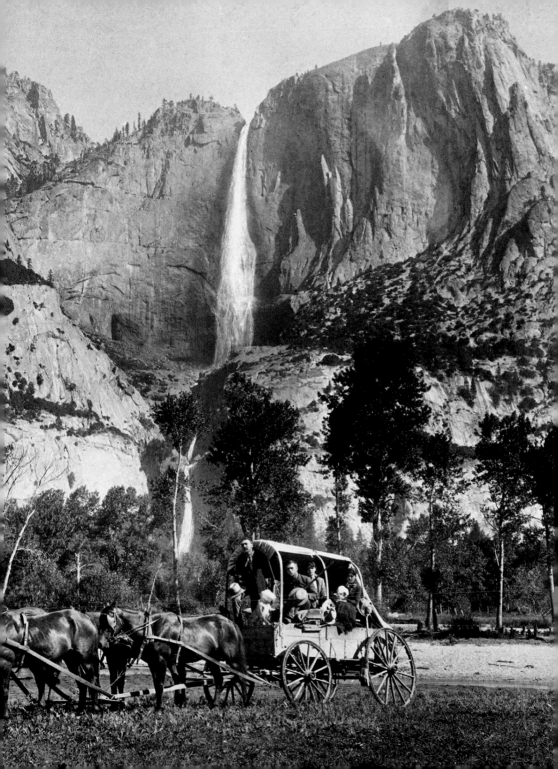

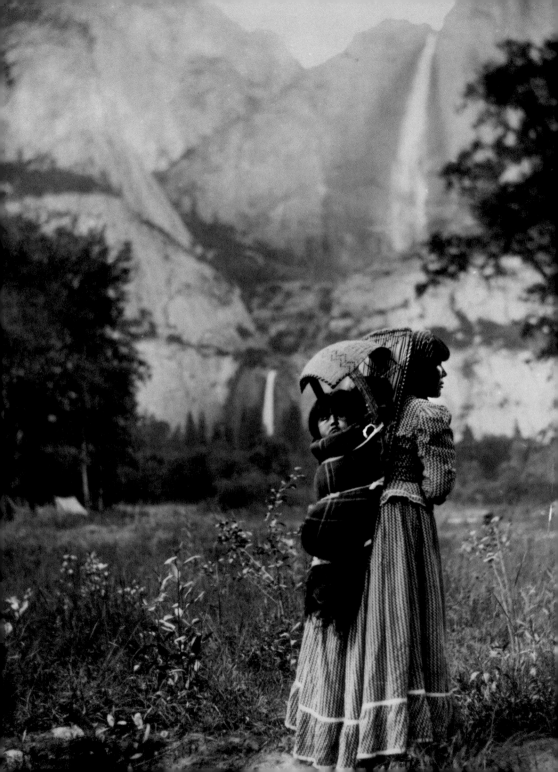

A HOME FOR GENERATIONS

Since time began, this land has been the ancestral home of the people now known as the Traditionally Associated Tribes of Yosemite National Park (the Bishop Paiute Tribe, Bridgeport Indian Colony, Mono Lake Kutzadika[a] Tribe, North Fork Rancheria of Mono Indians of California, Picayune Rancheria of Chukchansi Indians, Southern Sierra Miwuk Nation, and Tuolumne Band of Me-Wuk Indians). The people lived with the falls' cyclical roars and whispers.

The Valley was home to multiple villages, and the people took advantage of nearby resources growing in the meadows near the falls' base, such as acorns for food and willows and other materials for making woven baskets. The people actively tended the meadows with fire; regular burning of the landscape resulted in less dense tree growth and made Lower Yosemite Fall much more visible than it is today. Traditional ecological knowledge was passed down through the generations.

As high-country snow starts to melt, the surge of water that saturates meadows, streams, wetlands, and waterfalls is known as the "spring pulse."

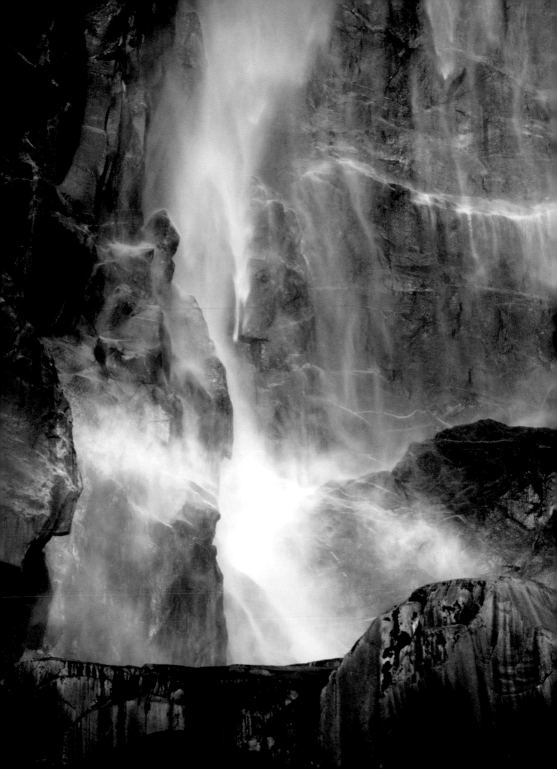

STOLEN LAND,
CHANGING TIMES

Drawn by the California gold rush of the mid-1800s, miners, herders, and homesteaders flocked to the Sierra Nevada, instigating waves of disease and displacement for the people living there. In the 1850s, the Mariposa Battalion, an armed militia, swept into the Valley on a state-sponsored campaign of genocide and destruction. They burned homes and food, killed multiple people, and chased others into hiding. During one foray, battalion members camped near the base of Yosemite Falls. Their written accounts extolled the landscape while dismissing the humanity of Yosemite's longstanding residents.

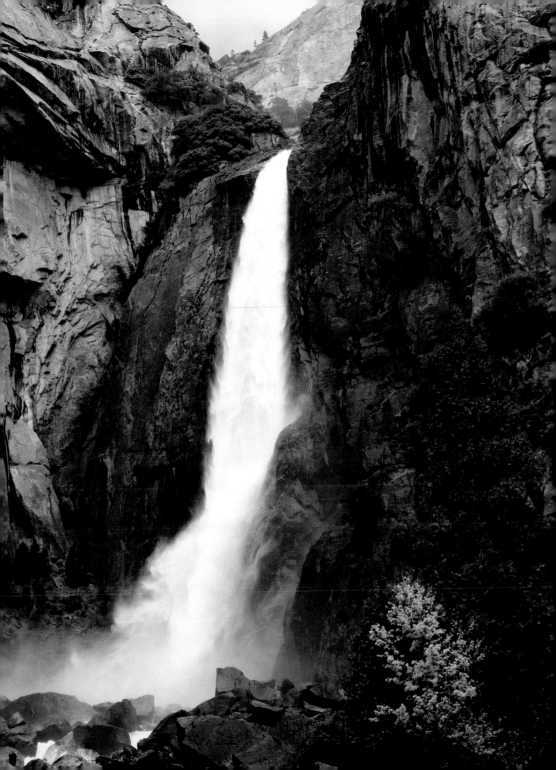

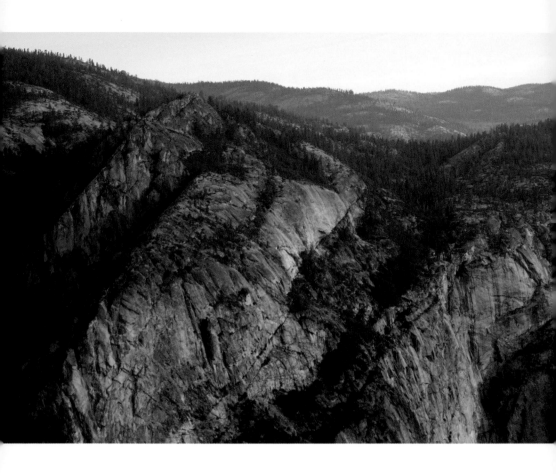

During this era, tales of the Valley's beauty spread across the continent and around the world. When James Mason Hutchings, a San Francisco–based publisher, heard rumors of a lofty waterfall in the Sierra Nevada, he headed to the Valley to see the wonder firsthand. The inaugural issue of *Hutchings' Illustrated California Magazine*, published in July 1856, featured a sketch of Yosemite Falls; accompanying text proclaimed that the feature was 2,500 feet tall (accurate), making it "the highest waterfall in the world" (not accurate).

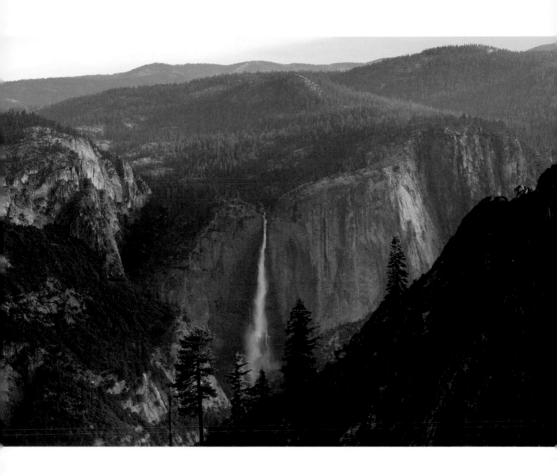

About a decade later, the 1864 Yosemite Grant Act gave California oversight of Yosemite Valley and the Mariposa Grove of Giant Sequoias—the first time the federal government protected land because of its scenic beauty. Tourism swelled. Hutchings himself built and ran a hotel and sawmill near Yosemite Falls. Recreational trails—some new, some following an extensive network of traditional trails— took shape. The steep route from the Valley floor to the top of Yosemite Falls, built in the 1870s, remains one of the park's most popular hikes.

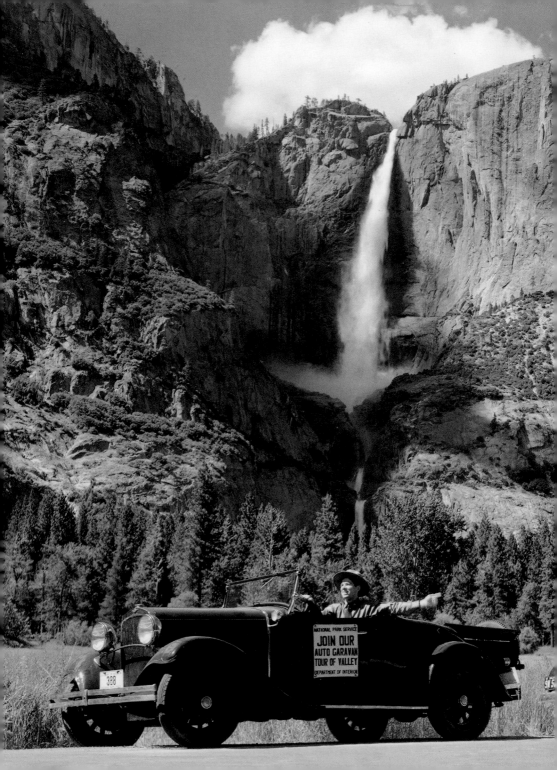

A NEW NATIONAL PARK

It's hard to imagine Yosemite without its signature waterfall, but when the national park was established in 1890, it didn't include Yosemite Falls. Clearly, that didn't last. Yosemite Valley and the Mariposa Grove remained under California's purview until 1906, when the federal government expanded the national park boundary to include those areas, in part to protect the watershed that feeds Yosemite Falls.

Yosemite Falls has long been one of the park's top attractions. When cars arrived in Yosemite in the early 1900s, black-and-white photographs captured drivers posing in open-top autos with the falls in the background. In the 1920s, the new Yosemite Village sprouted near the base of the falls, creating a hub of services and amenities that still exists today, now including hotels, stores, eateries, a post office, and a museum.

Some of the people native to Yosemite lived among the growing non-Native population, often working for the National Park Service so they could stay in their ancestral home. After numerous attempts to remove the people, the NPS demolished their last village in the Valley in the 1960s, at the Wahhoga site, just west of Yosemite Falls. Today Yosemite's Traditionally Associated Tribes regularly consult on matters relating to the park and hold events within its borders. For more on tribal history, practices, and ongoing stewardship in the Yosemite area, read *Voices of the People* (see Resources, starting on p. 62).

TWENTY-FIRST CENTURY STEWARDSHIP

Even something as commanding as Yosemite Falls needs a little extra care every so often, especially when it comes to ensuring its long-term ecological health. The base of the lower fall, for example, was once marked by a crowded parking lot and crumbling pavement that threatened the area's vegetation and wildlife habitat. A major restoration project transformed that area with accessible paths, educational exhibits, restrooms, and picnic spots. The NPS is working with the Traditionally Associated Tribes to regenerate nearby black oak stands, relying on traditional stewardship practices and tribal volunteers to ensure that cultural knowledge is not forgotten.

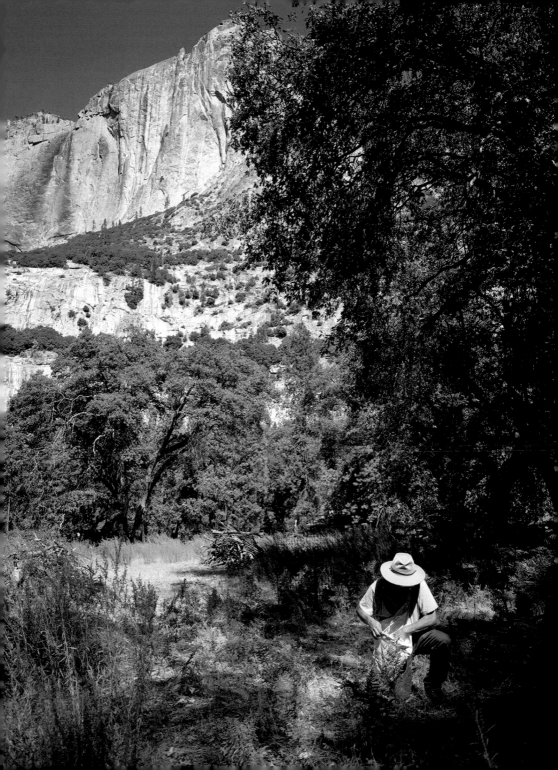

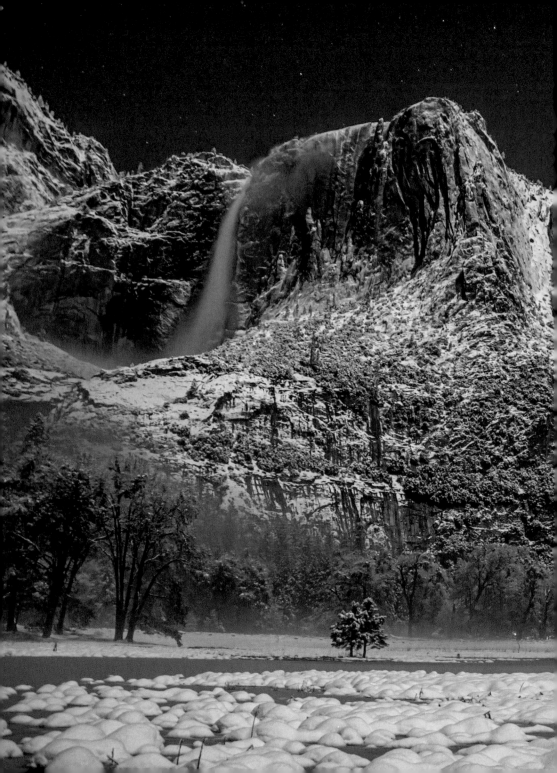

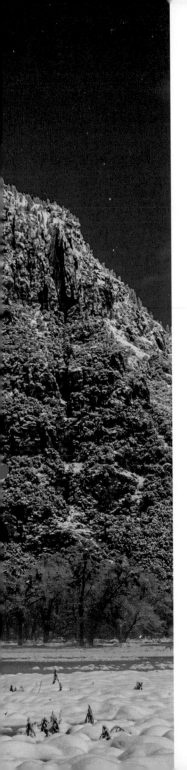

Every year, NPS crews clean up the area around the falls' base and the trail to Upper Yosemite Fall. They remove debris, fix walls and drains, and make sure pedestrian routes are safe. Do those crews a favor: When hiking, follow curves and switchbacks, even when it's tempting to skip them. Those zigzags may add extra steps, but they're in place for a reason; shortcuts can hasten erosion of the trail and put visitors at risk of twisted ankles or worse.

In addition to being a world-class attraction, Yosemite Falls is also an outdoor classroom. There's a lot to learn from the falls about hydrology and geology, water-loving plants and animals, and, of course, climate change. As temperatures rise in the Sierra Nevada, a higher percentage of precipitation is arriving as rain, instead of snow. The winter snow that does fall melts earlier in the spring. How will the seasonal cycle of Yosemite Falls transform if the snow that feeds it vanishes? Will Yosemite Falls roar for future generations if the Sierra Nevada, "the snowy range," no longer lives up to its name?

The name Yosemite Falls is plural because it's made up of multiple connected waterfalls. If you see a waterfall with a singular name (as in Vernal Fall), that means the feature has just one continuous drop.

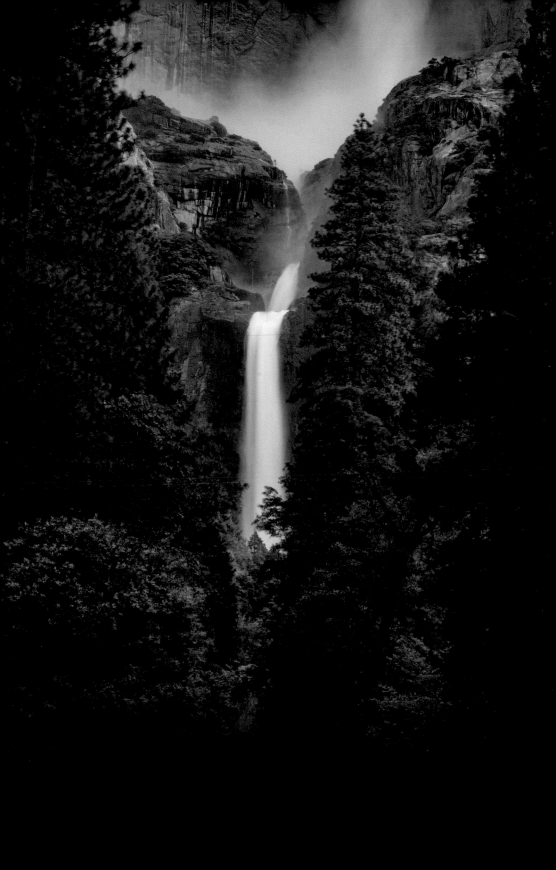

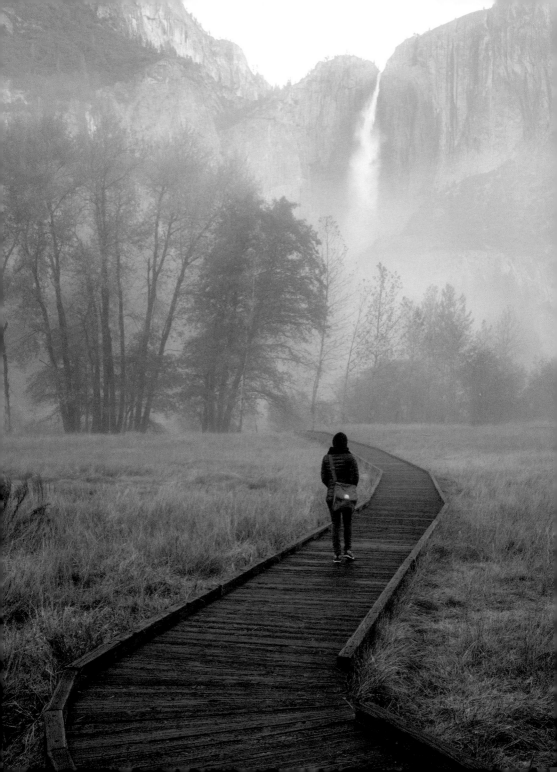

Visiting Yosemite Falls

Yosemite Falls is a multisensory experience. You can watch it morph with the seasons, hear the rumbling snowmelt, feel the spray, and smell the damp earth. Read on to learn how to safely experience it from different parts of the park, whether taking in the view from a Valley meadow or standing right in the spray.

THE BASICS

For a classic close encounter with Yosemite Falls, follow the short Lower Yosemite Fall Trail (1 mile/1.6 km). Much of the shady loop, which starts at a shuttle stop about a half-mile (0.8 km) east of the Yosemite Museum, is smooth and flat enough for wheelchairs and strollers.

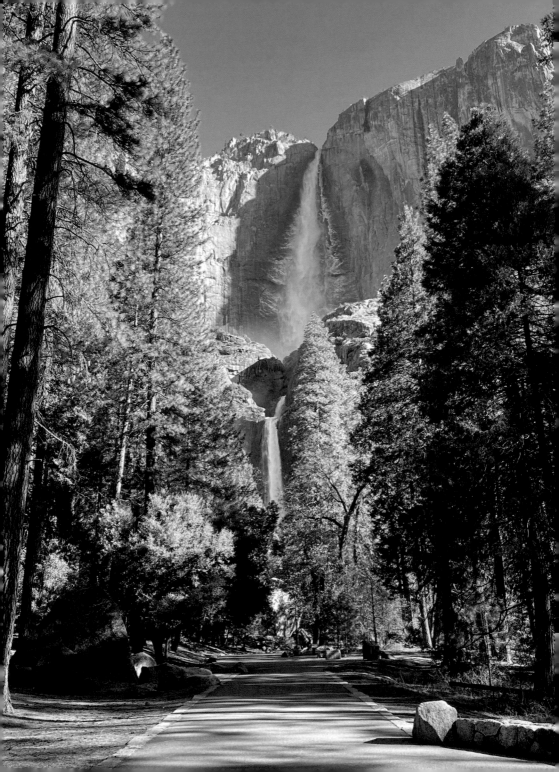

As you start following the loop clockwise from the trailhead, you'll get a magnificent view of Lower Yosemite Fall framed by tall pines. As you continue along the trail, look for a bronze model of the falls and surrounding topography. Pour water into the metal map's grooves to see how it flows through the terrain.

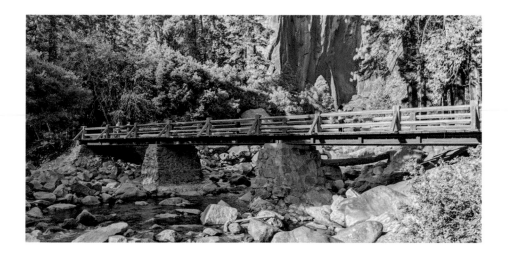

When you reach the bridge and viewing area at the bottom of the lower fall, enjoy the mist— or, depending on the season, the deluge. In winter, listen for ice plummeting into a frosty heap at the falls' base. On spring mornings, watch frozen spray form slushy frazil ice in the creek.

The base of the falls is often busy, but your patience will be rewarded. The view is definitely worth the wait, but it's not worth risking your safety. Stay on designated paths and behind railings. Even seemingly dry creek-side rocks can be slippery, and plants will appreciate not being trampled.

Once you've had your fill of the splashing, thundering snowmelt, keep heading clockwise to complete the loop. As you make your way back toward Northside Drive, a short path leading west off the main trail will take you to the Galen Clark Memorial Bench. Clark, who served as the state-appointed manager of the Valley and the Mariposa Grove for several decades in the 1800s, proposed the idea for this stone bench late in his long life. Clark never got to take in the view from this seat by Yosemite Creek (it was installed in 1911, the year after his death), but you can.

UP, UP, UP

If you have a full day to spare, are craving a strenuous hike, and wonder what a waterfall looks like from above, head for the Yosemite Falls Trail, which begins near Camp 4. The first mile (1.6 km) zigzags up 1,000 feet (305 m) to the Columbia Rock overlook. Stop and savor views of Half Dome, North Dome, and Cathedral Rocks.

If you're aiming for the top of the falls, allow at least six hours to cover the 7.2-mile (11.6 km) round-trip route, an arduous ascent featuring oaks and pines, loose rock, protected but steep drop-offs, and scenic spots for snack breaks. Bring plenty of water with you: The hike is strenuous in any season, and there is nowhere along the trail to safely refill water bottles.

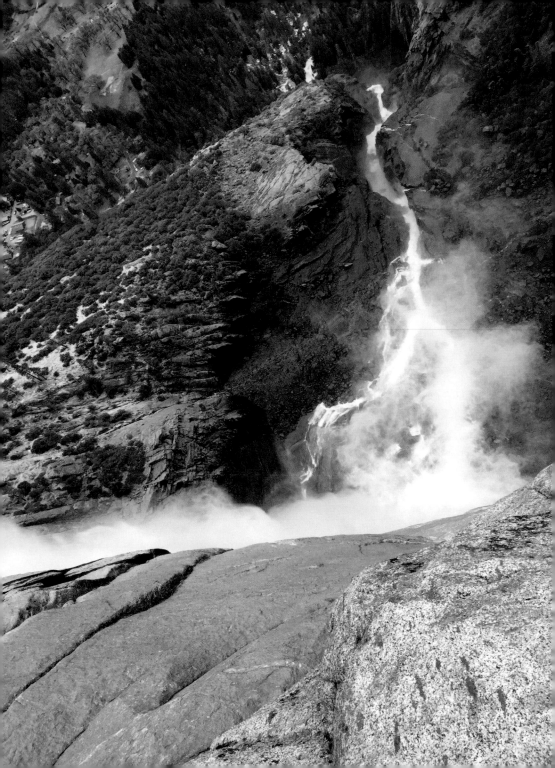

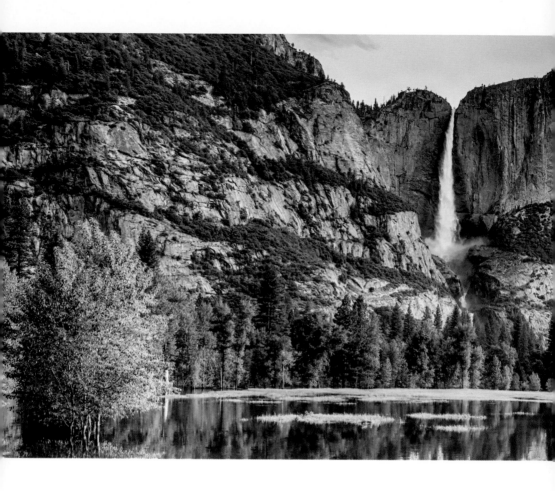

At the top, you'll get to see Yosemite Creek just before it spills over the Valley's rim. The creek bed is extremely slick, and a misstep could be fatal, so use caution and stay far from the water's edge. For an extra-close look, descend narrow stone steps to a guardrail-lined ledge and peer down Upper Yosemite Fall. If you're in the mood for a few more steps, extend your hike another 0.75 mile (1.2 km) and 410 feet (125 m) up to Yosemite Point for a head-on look at Half Dome's face.

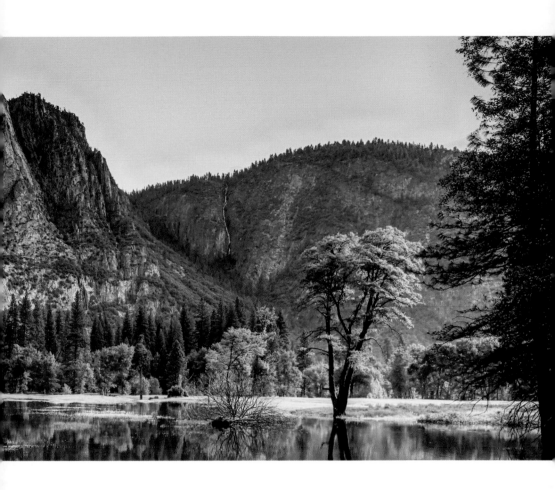

WIDER PERSPECTIVE

The trails to the lower and upper falls put you face-to-face with the water. If you want to contemplate Yosemite Falls from a wider (and dryer) angle, try one of these spots.

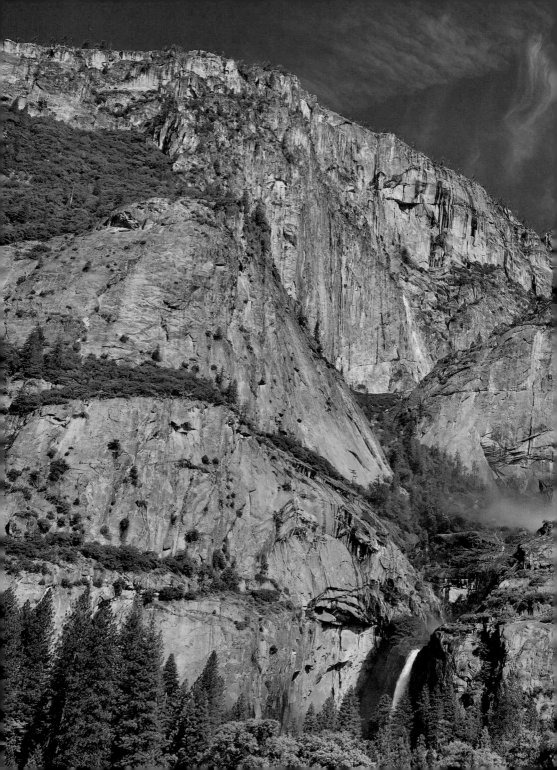

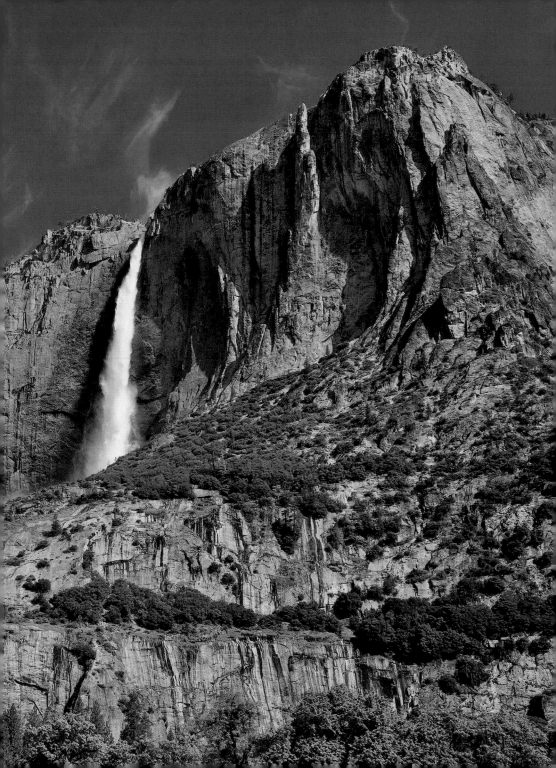

From the Valley's meadow boardwalks, get creative with your sightseeing: Search for Yosemite Falls mirrored in shallow pools, use tree trunks as impromptu photo frames, and marvel at how even towering pines and tour buses look toy-sized below the tumbling water. Swinging Bridge boasts one of the most famous views of Upper Yosemite Fall; on calm days, you'll see the waterfall reflected in the Merced River.

The upper and lower falls are easy to see, but it's harder to catch a glimpse of the middle cascades. To get a look at the entirety of Yosemite Falls in one go, head to the south side of the Valley. The Four Mile Trail, Glacier Point, Pohono Trail, and Sentinel Dome all offer views of the entirety of Yosemite Falls, including the elusive central section. When the falls are in full force, you can hear the deep drumroll of water reverberating all over eastern Yosemite Valley.

EMBRACING CHANGE

Yosemite Falls peaks in spring, but we'll let you in on a secret: This icon shines in autumn, too, when wet weather revives a gentle flow, and black oaks, cottonwoods, and aspens wave their golden leaves in the foreground. Don't miss the winter show either, when snowy cliffs make the water—sometimes a trickle, sometimes a torrent, depending on the weather—seem to gleam even brighter.

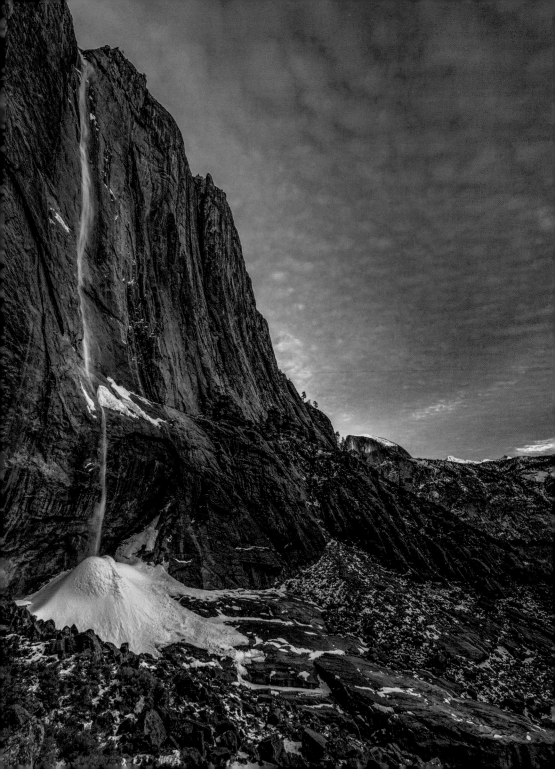

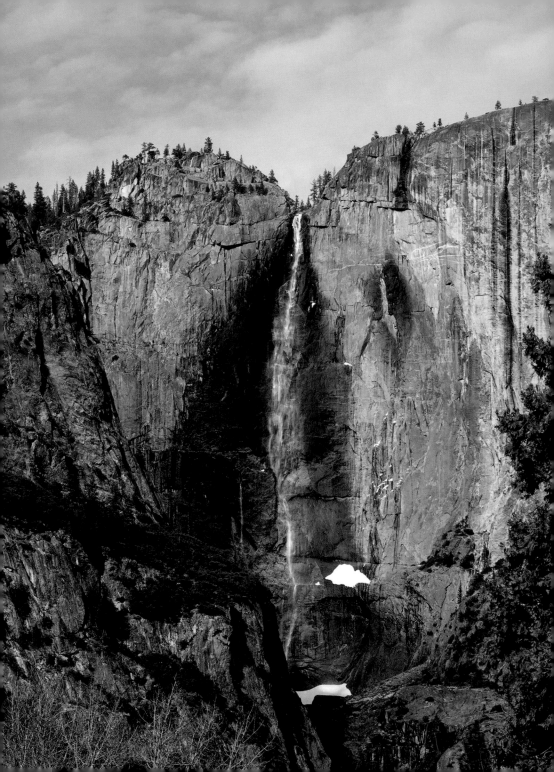

In the summer, when the water slows or stops, the Yosemite Falls area is still worth a visit. East of the falls, you can explore Yosemite Village, stop by the Yosemite Cemetery to ponder the lives behind the headstones, and visit the reconstructed version of a Native village. The village, which includes a roundhouse, acorn granaries, and bark-covered dwellings, serves as an educational space and an actively used cultural and community site. West of the falls, the Wahhoga area is being rebuilt into a long-planned Indian Cultural Center.

As the water dwindles, look for dark streaks on the cliff outlining the shape of the absent falls. But are they stains? Or shadows?

Not quite. What you're seeing is communities of lichens that thrive on the wet rock. The water-loving organisms go dormant in the summer sun, waiting, like the rest of us, for the falls to return.

Yosemite Falls may not be a steady presence, but it's unquestionably a mighty one. Here, you can witness a small piece of a creek's long journey, the push and pull of seasons, and the power and vulnerability of the Sierra Nevada snowpack. You may find yourself drawn back over and over, even stopping by multiple times in a single day, to see how this icon will impress or intrigue you next. And every time, we bet you'll experience something new.

Yosemite's icons are far more than immense, stunning natural features. They also tell us about the park's past and present, and they prompt questions about its future. How can you help protect this iconic place for future generations?

RESOURCES

Check out these resources for more in-depth information on Yosemite, including natural and human history, things to see and do, places to stay, and ways to help protect the park.

Yosemite National Park: The National Park Service manages Yosemite National Park and is your best resource for the most comprehensive and up-to-date information about visiting the park, current conditions, natural resources, history, safety, and more.

WEBSITE: nps.gov/yose. For **trip-planning tips** go to nps.gov/yose/planyourvisit. **CALL:** 209.372.0200 (general questions). For questions related to trip-planning and permits for the Yosemite Wilderness, call 209.372.0826 (in service March through September).

Yosemite Conservancy: As Yosemite National Park's cooperating association and philanthropic partner, the Conservancy funds important work in the park and offers a variety of visitor resources and activities, including art classes, guided Outdoor Adventures and Custom Adventures, volunteer programs, and bookstores. The $13.5 million restoration project at Lower Yosemite Fall was made possible through the partnership between the National Park Service and Yosemite Conservancy donors.

WEBSITE: yosemite.org. To see the Conservancy's four **Yosemite webcams**, including one aimed at Yosemite Falls, visit yosemite.org/webcams. **CALL:** 415.434.1782

Yosemite Hospitality: A subsidiary of Aramark, Yosemite Hospitality, LLC, is an official concessioner of Yosemite National Park, and it operates hotels, restaurants, stores, visitor programs, and more.

WEBSITE: travelyosemite.com
CALL: 888.413.8869 (U.S.) or 602.278.8888 (International)

The Ansel Adams Gallery: Located in Yosemite Village, the gallery celebrates Ansel Adams's work and legacy, showcases other photographers who capture the American West, and offers photography workshops.

WEBSITE: anseladams.com **CALL:** 209.372.4413

Voices of the People: This book by the Traditionally Associated Tribes of Yosemite National Park (Bishop Paiute Tribe, Bridgeport Indian Colony, Mono Lake Kutzadikaª Tribe, North Fork Rancheria of Mono Indians of California, Picayune Rancheria of the Chukchansi Indians, Southern Sierra Miwuk Nation, Tuolumne Band of Me-Wuk Indians) offers detailed information and insights from the people native to the Yosemite area. Published by the National Park Service in 2019, **Voices of the People** is available from Yosemite Conservancy and digitally from most e-book vendors.

Yosemite Nature Notes: This series of short documentaries about Yosemite dives into the park's geology, ecology, human stories, and more. For Yosemite Falls–related content, see Episode 2 ("Yosemite Falls"), Episode 9 ("Frazil Ice"), Episode 15 ("Moonbows"), and Episode 18 ("Water"). Find all **Yosemite Nature Notes** episodes on the Yosemite National Park website (nps.gov/yose/learn/photosmultimedia/ynn.htm).

PHOTO CREDITS

1: Yosemite Falls snow. Photo by Guy Miller.
2, 3: Yosemite Falls from Four Mile Trail. Photo by Michael Wackerman.
4, 5: Halfway up. Photo by Sam Goodgame on Unsplash.
6, 7: Plunging waters, Yosemite Falls. Photo by Greg Coit.
8, 9: Rare autumn recharge. Photo by Yosemite Conservancy/Adonia Ripple.
11: Living life on the edge. Photo by Clarice Henry.
12, 13: Mount Hoffmann near the headwaters of Yosemite Creek. Photo by Gretchen Roecker.
14, 15: Lost Arrow Spire. Photo by Greg Coit.
17: Yosemite Falls split with cloud. Photo by Dakota Snider.
18, 19: Three Brothers. Photo by John Milam.
21: Moonbow. Photo by Guy Miller.
22, 23: Exploring a mossy boulder near Lower Yosemite Fall. Photo by Keith S. Walklet.
24: American dipper. Photo by iStock.com/stevelenzphoto.
25: California sister butterfly. Photo by Carolyn Trimble Botell.
26, 27: Dogwood and Yosemite Falls. Photo by Jean Slavin Photography.
28, 29: Sierra fence lizard. Photo by istock.com/Sundry Photography.
30, 31: In Yosemite in early days. Photo by Hildreth, copied by Ralph H. Anderson. Courtesy of the Yosemite National Park Archives, Museum and Library, RL_02532.
32: Sadie and Suzie McGowan, c. 1900. Photo by J. T. Boysen. Courtesy of the Yosemite National Park Archives, Museum and Library, RL_14120.
35: Mistbow. Photo by Karl Anderson on Unsplash.
36, 37: Lower Yosemite Fall. Photo by Tom Gainor on Unsplash.

38, 39: Sunrise from Taft Point. Photo by Michael Wackerman.
40, 41: Auto caravan in Yosemite Valley. Courtesy of the Yosemite National Park Archives, Museum and Library, RL_015919.
43: A member of the Mono Lake Kutzadika[a] Tribe gathers acorns for black oak restoration. Photo by Yosemite Conservancy/Ryan Kelly.
44, 45: Yosemite Falls at night. Photo by Dakota Snider.
47: Yosemite Falls. Photo by Perry Kibler on Unsplash.
48: Chapel Meadow boardwalk. Photo by Keith S. Walklet.
50: Lower Yosemite Fall Trail. Photo by Eric Ball.
51: Lower Yosemite Fall footbridge. Courtesy of NPS.
53: Via Aqua. Photo by Greg Coit.
54, 55: Spring flood. Photo by Mick Haupt on Unsplash.
56, 57: Yosemite Falls in late spring. Photo by Michael White.
58: Upper Yosemite Fall and snow cone. Photo by Phillip Nicholas.
60: Upper Yosemite Fall before spring pulse begins. Photo by Robby McCullough on Unsplash.
Back cover: Iconic waterfall. Photo by Mick Haupt on Unsplash.

Text copyright © 2022 by Yosemite Conservancy
Photography credits can be found on pages 63–64.

Published in the United States by Yosemite Conservancy.

YOSEMITE
CONSERVANCY.

yosemite.org

Yosemite Conservancy inspires people to support projects and programs that preserve Yosemite and enrich the visitor experience.

Text by Gretchen Roecker
Book design by Eric Ball Design
Cover art by Shawn Ball

ISBN 978-1-951179-20-5

Printed in China by Reliance Printing

1 2 3 4 5 6 – 26 25 24 23 22

MIX
Paper from
responsible sources
FSC® C102842